EMOJI CHRISTMAS
POCKET SIZE COLORING BOOK

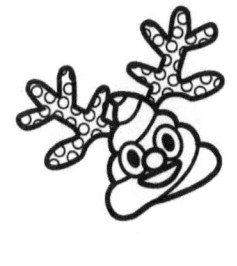 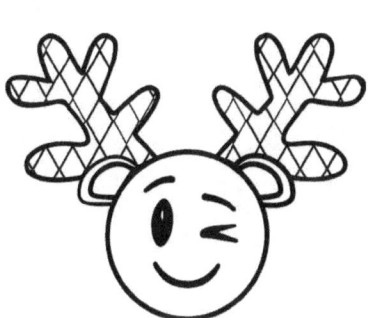 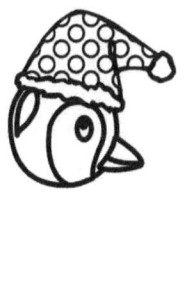

24 COLORING PAGES

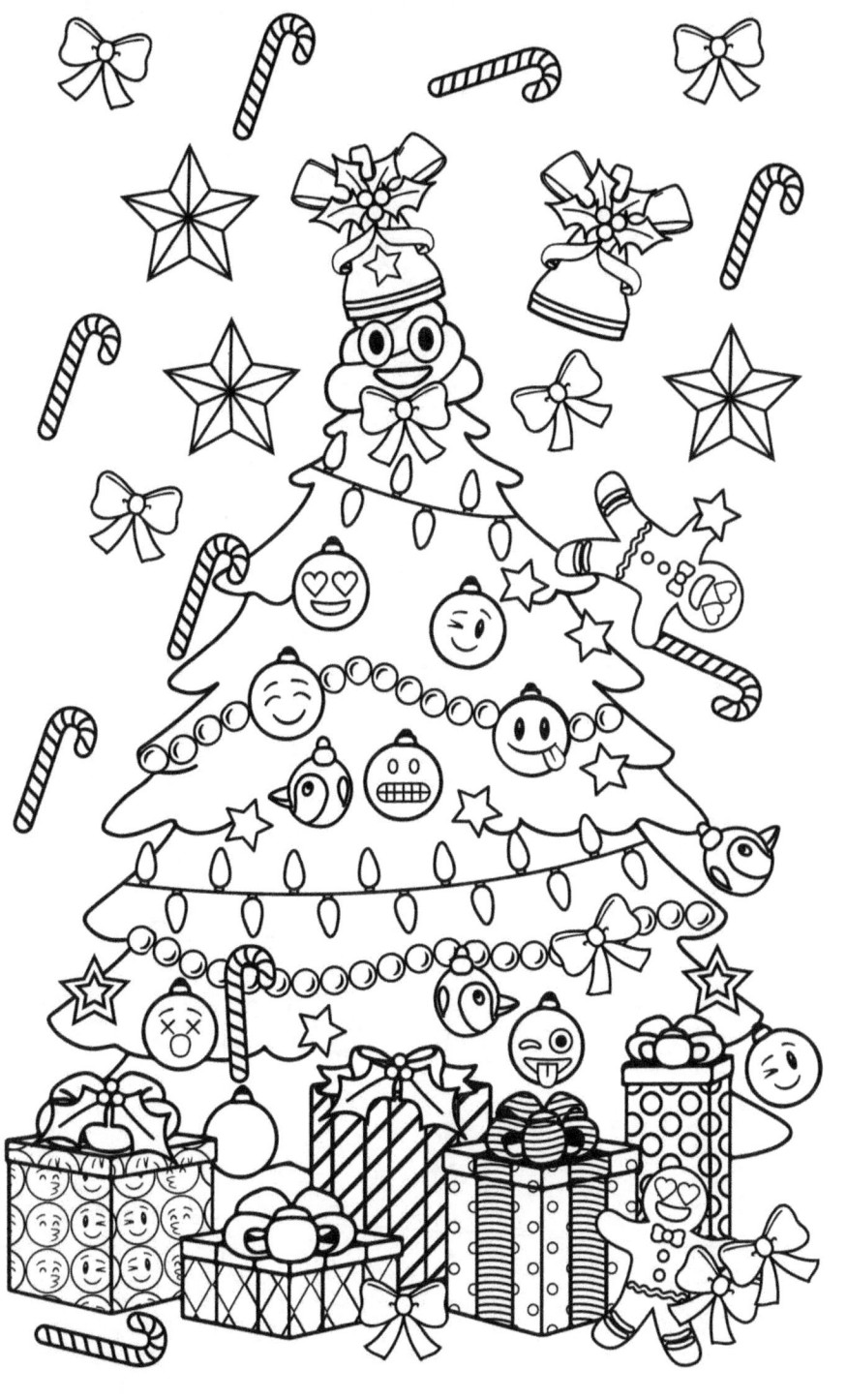

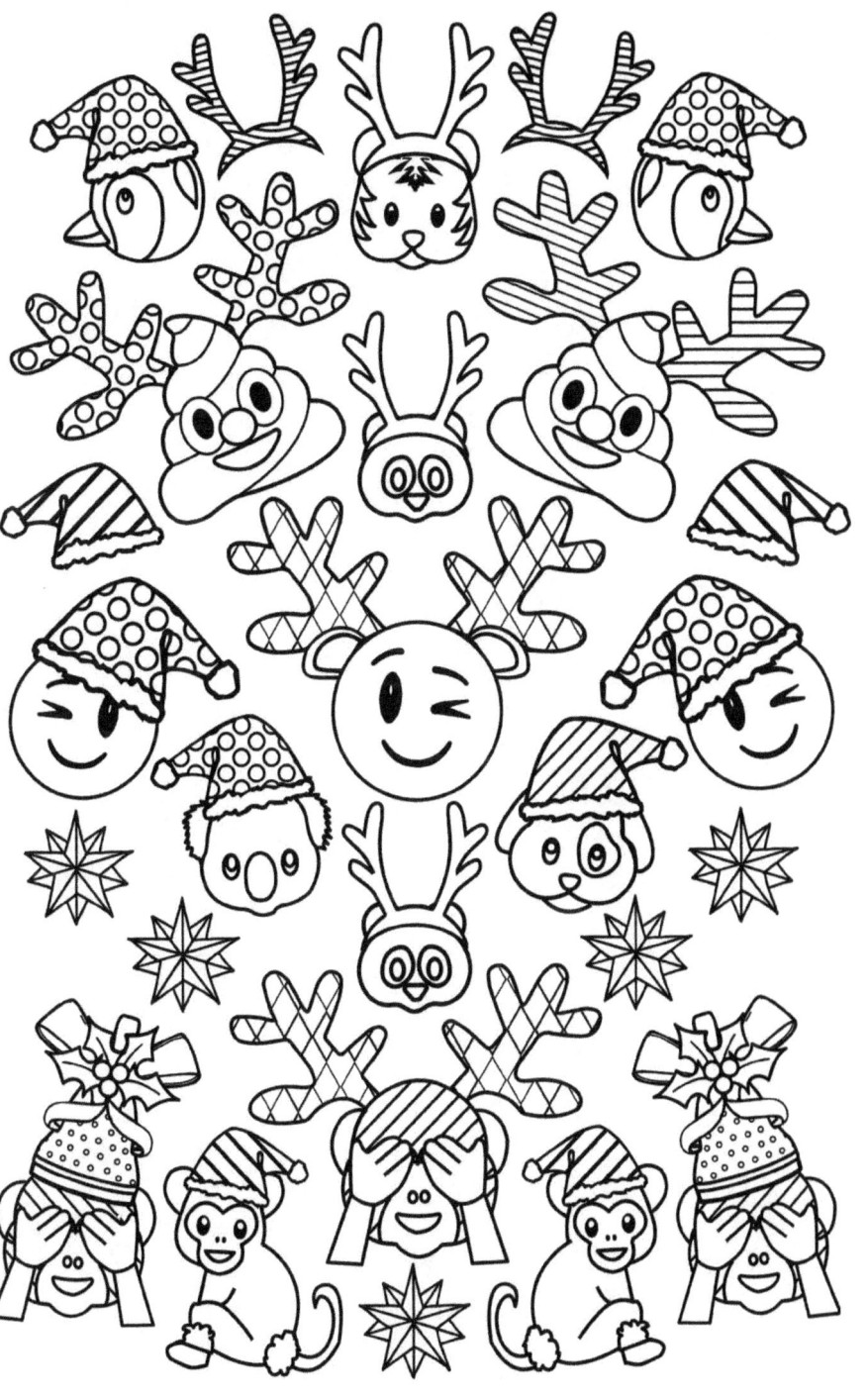

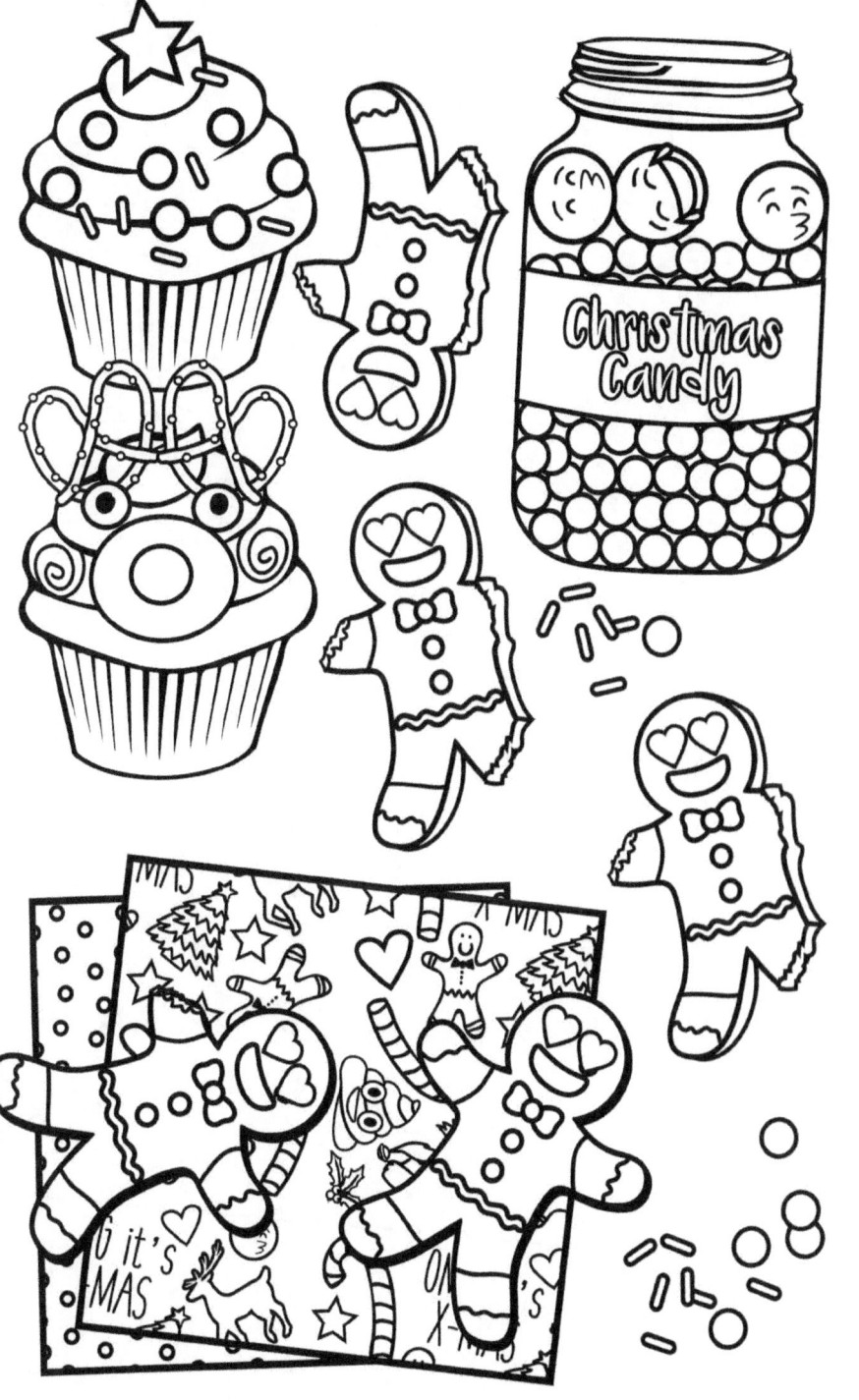

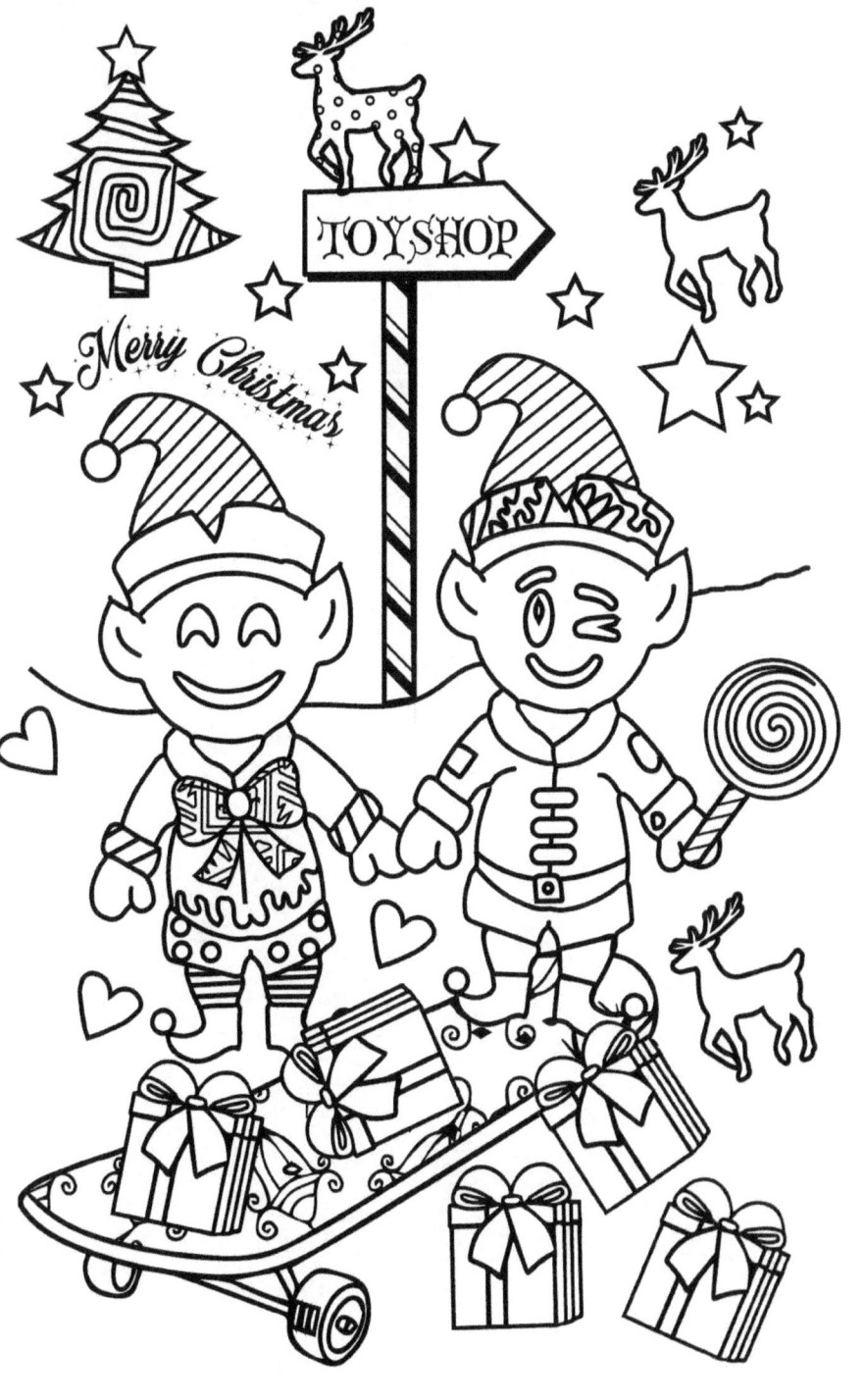

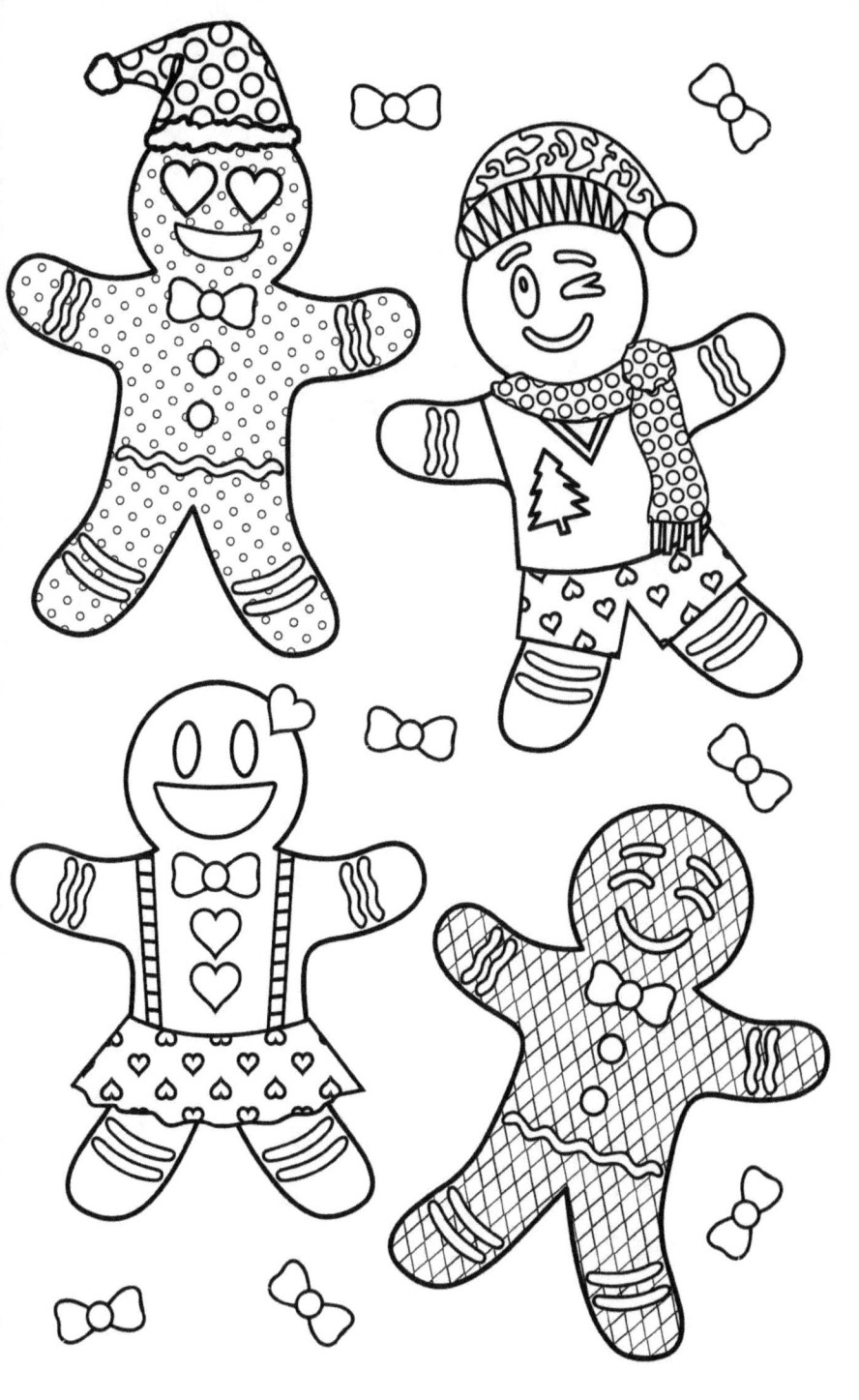

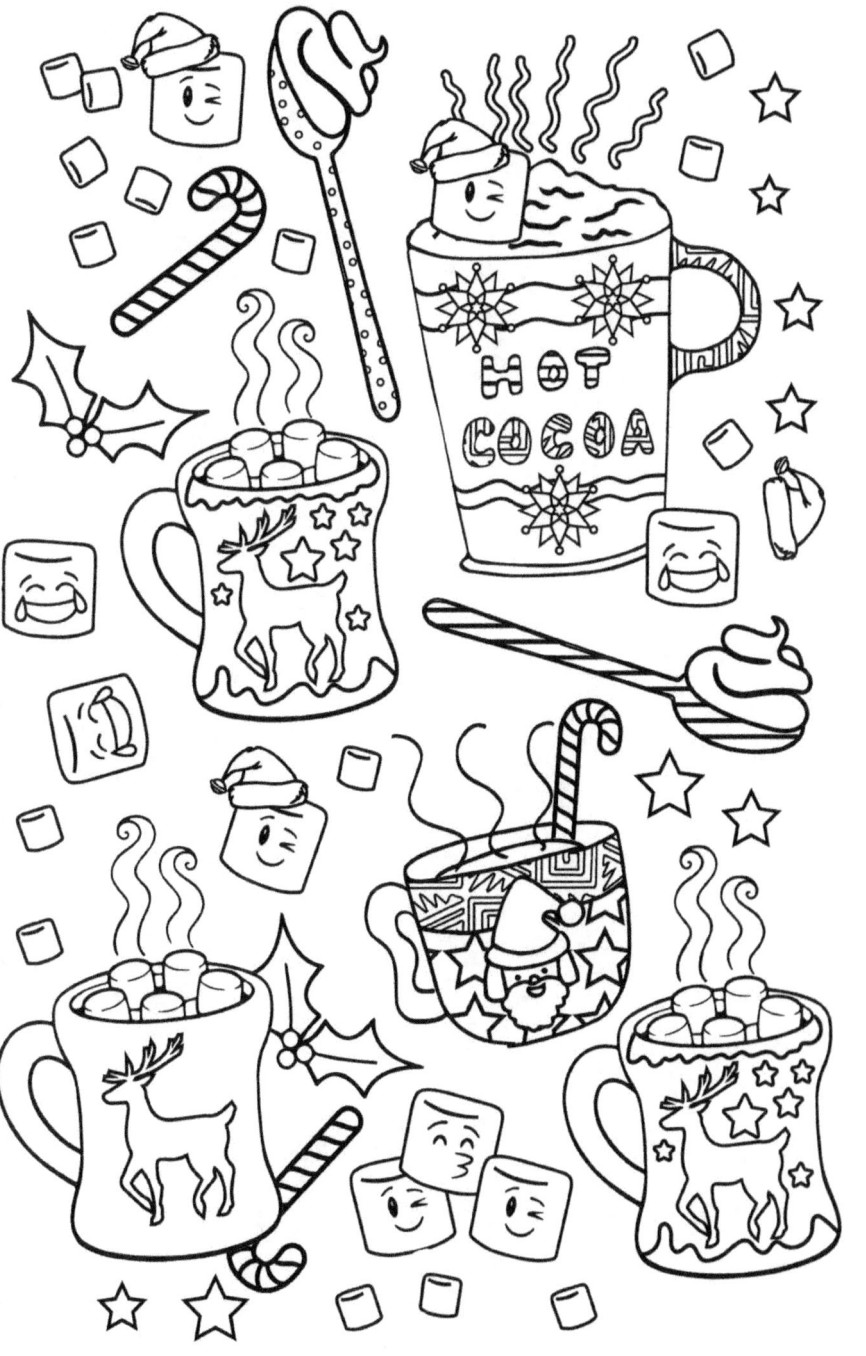

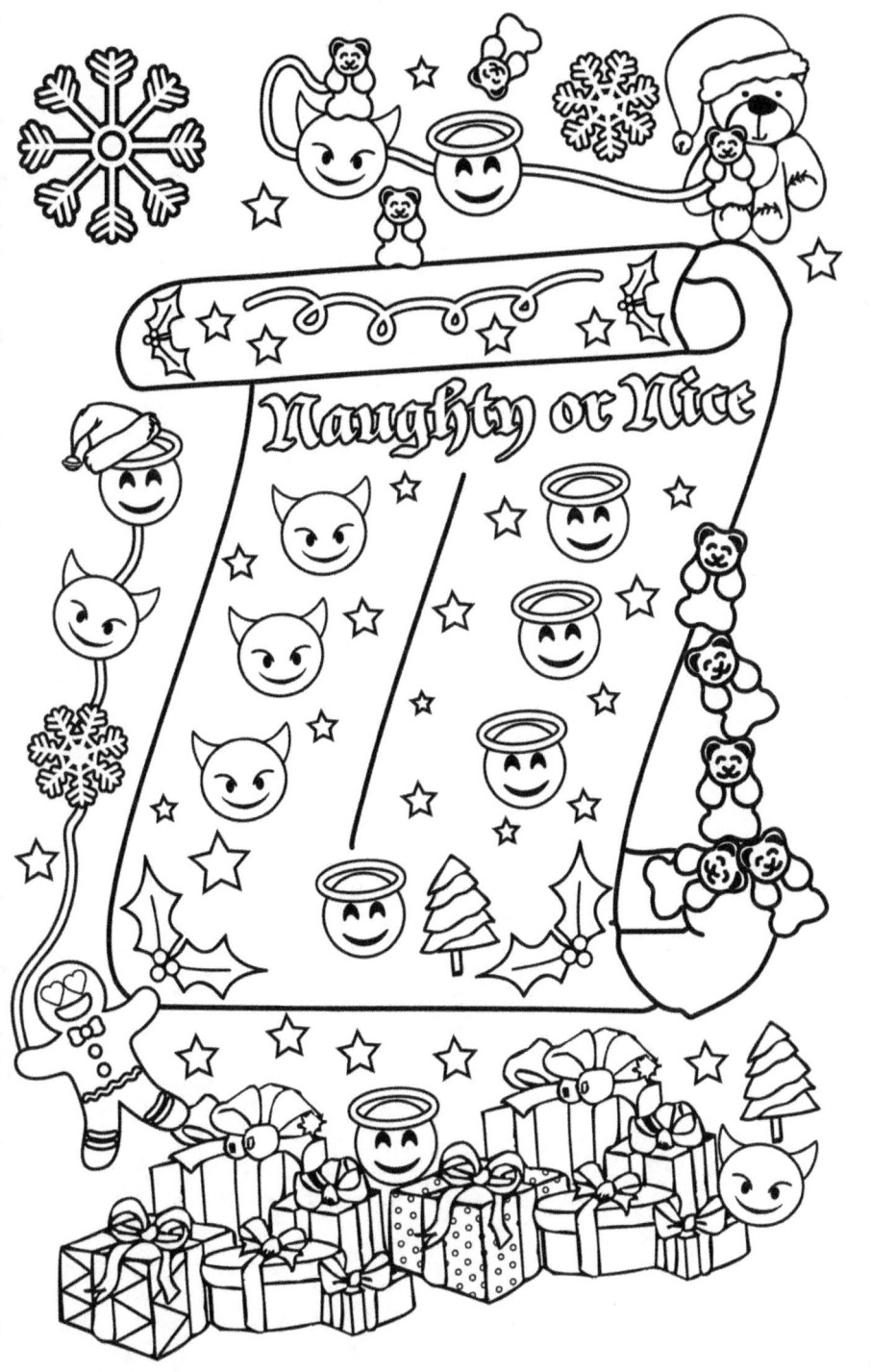

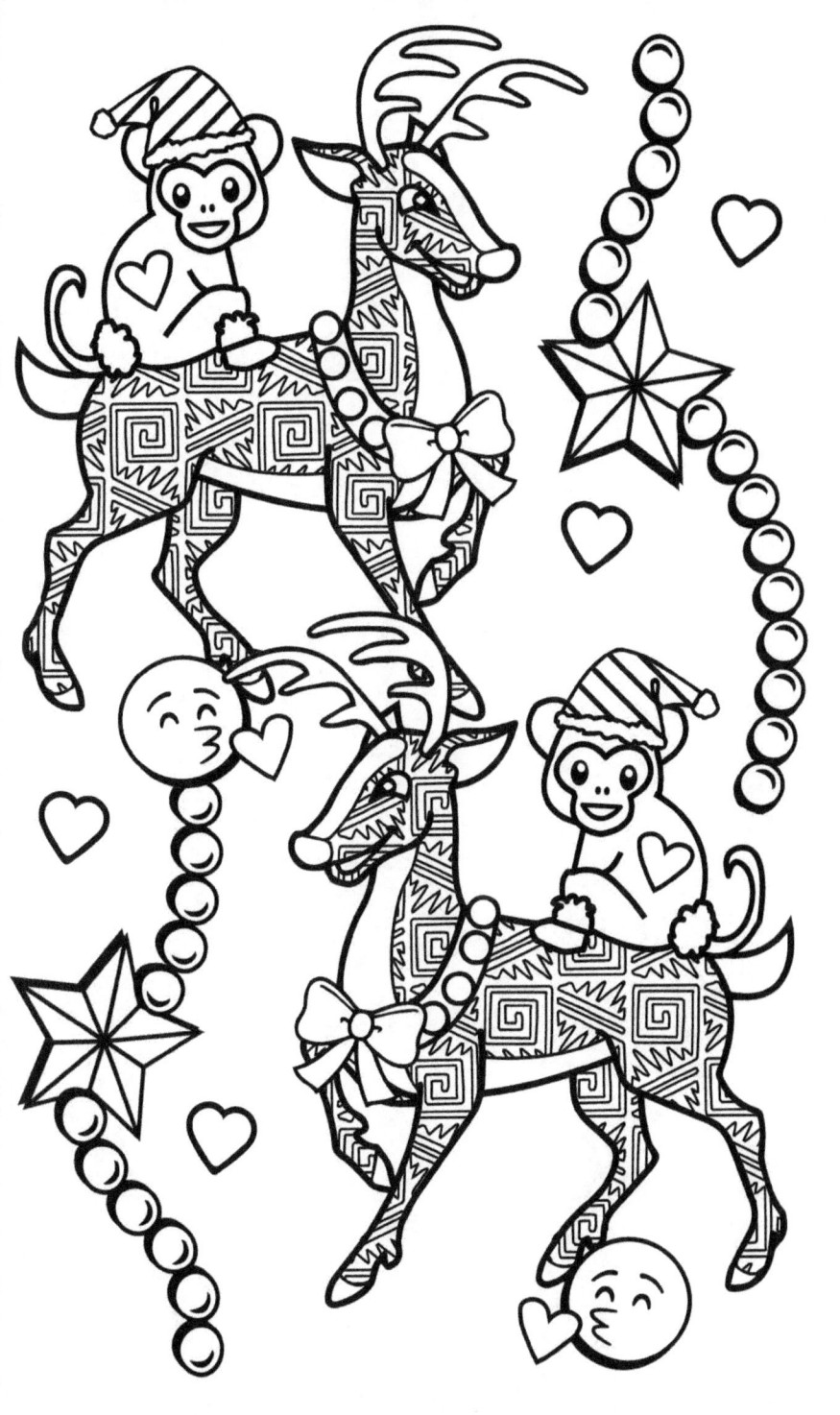

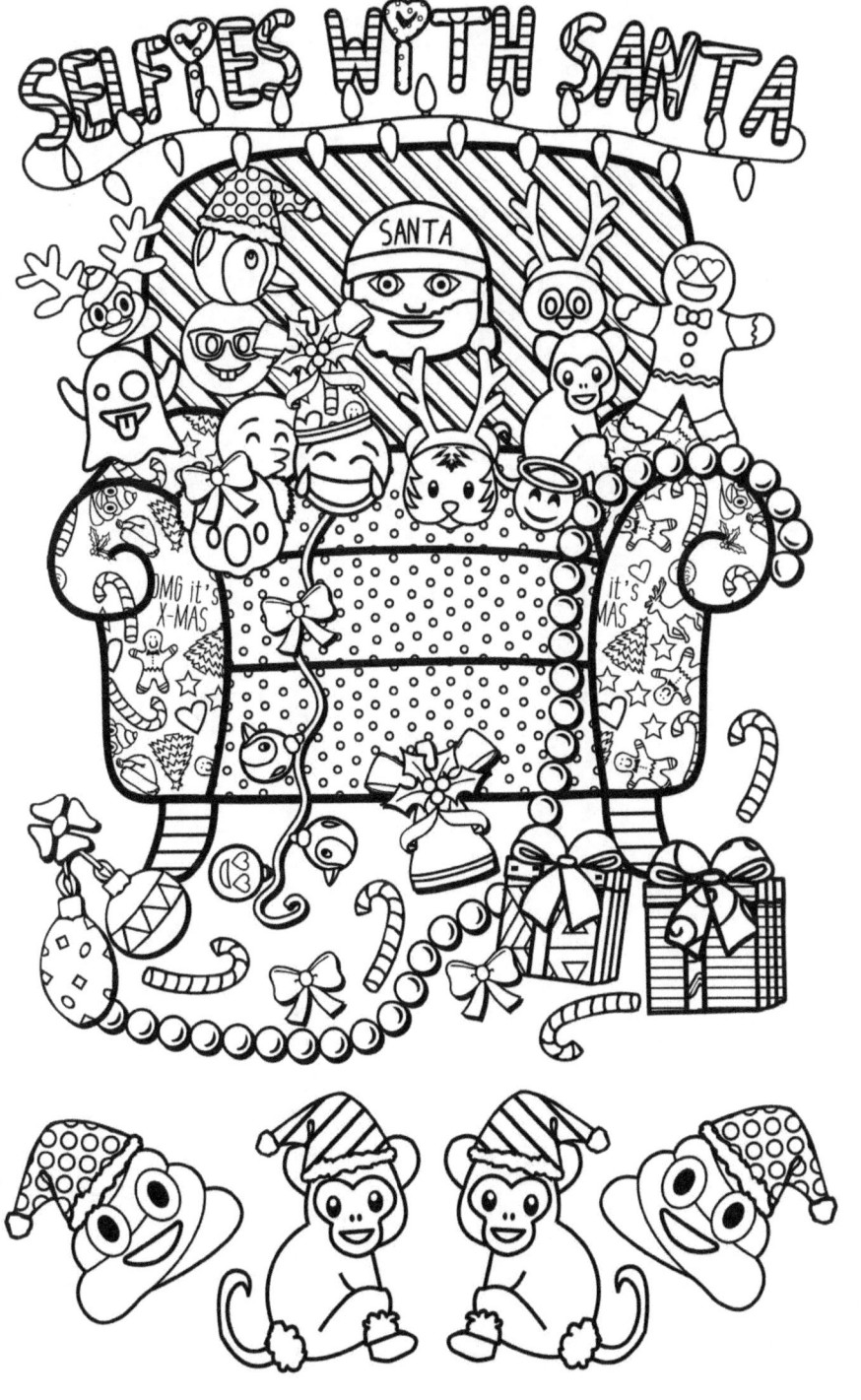

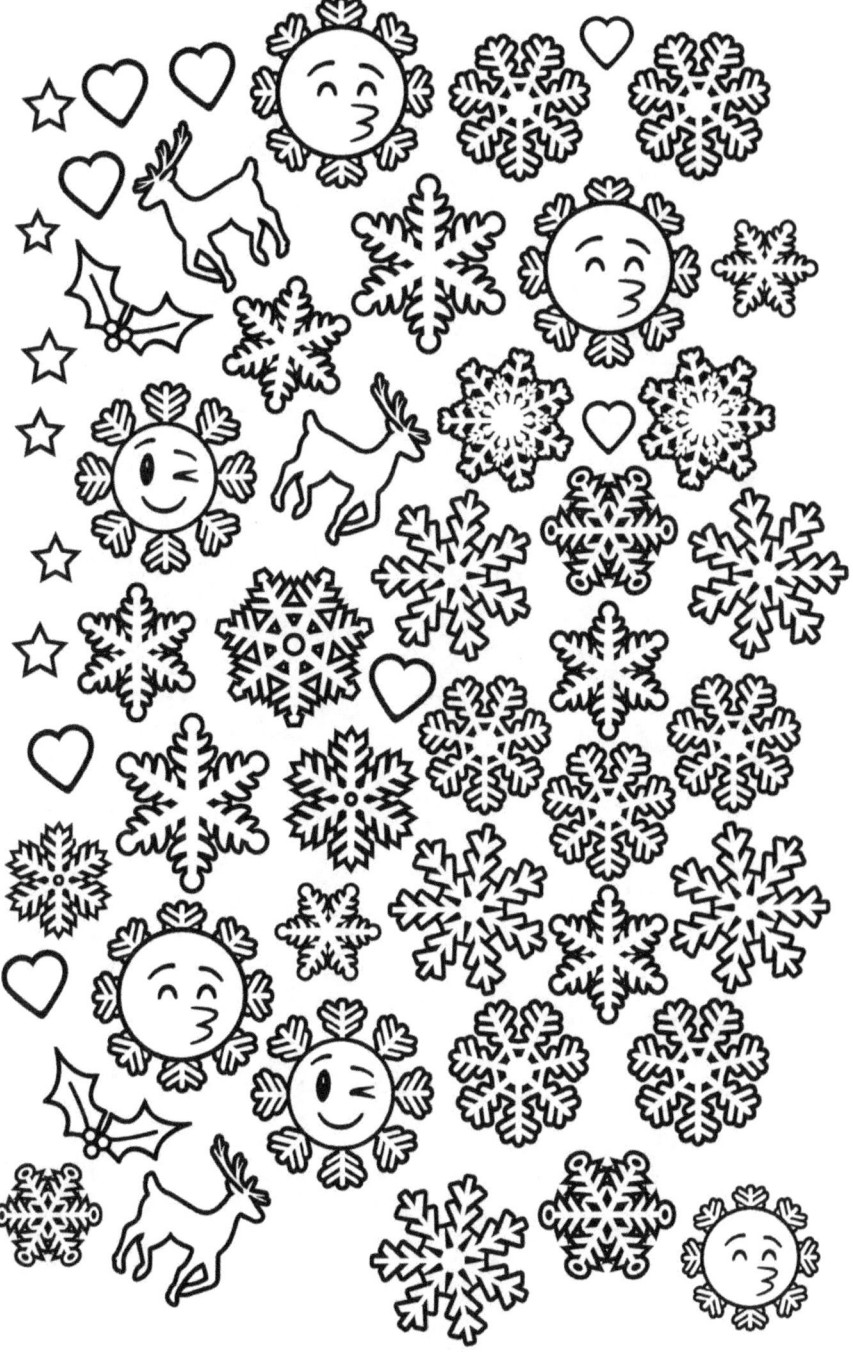

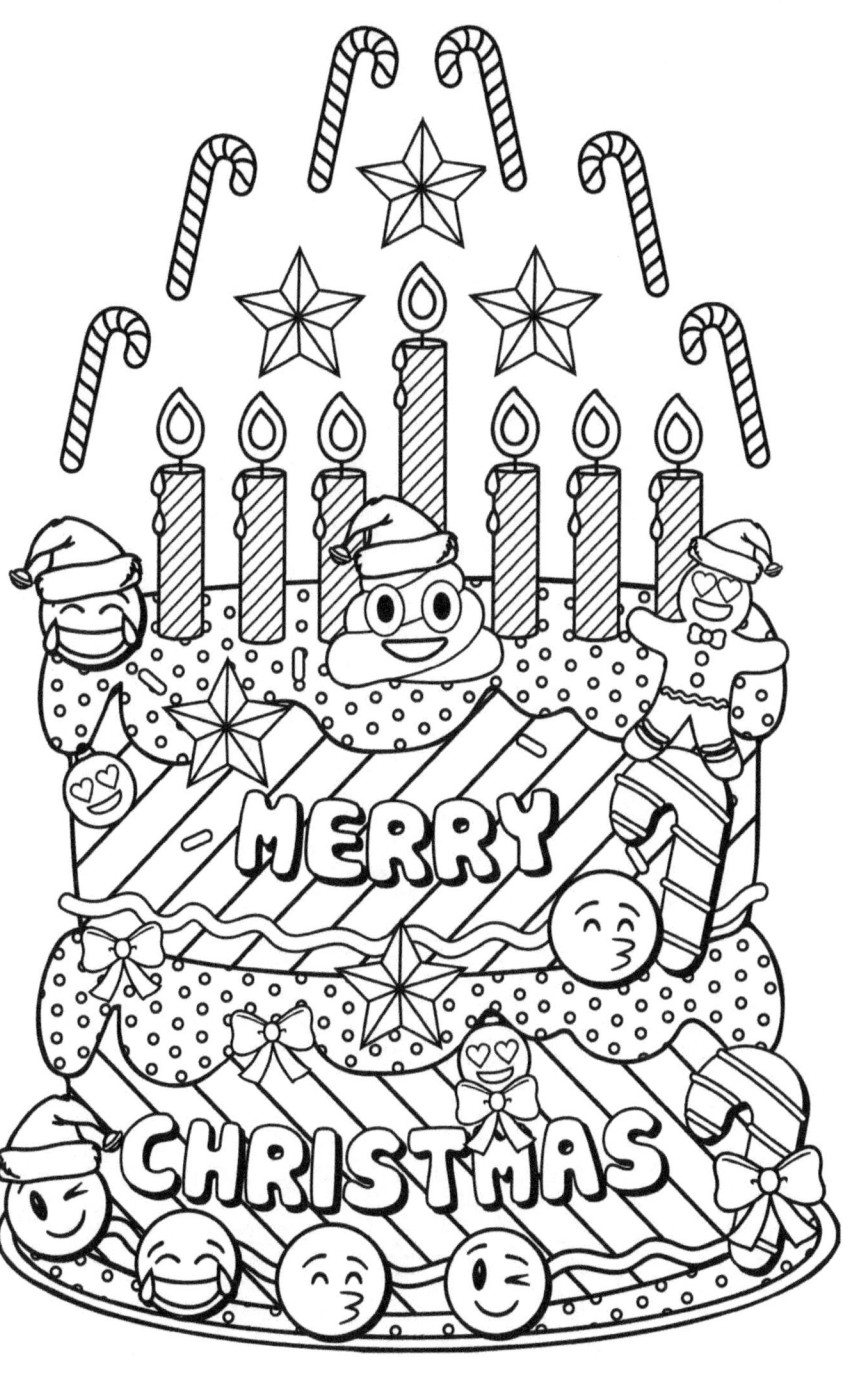

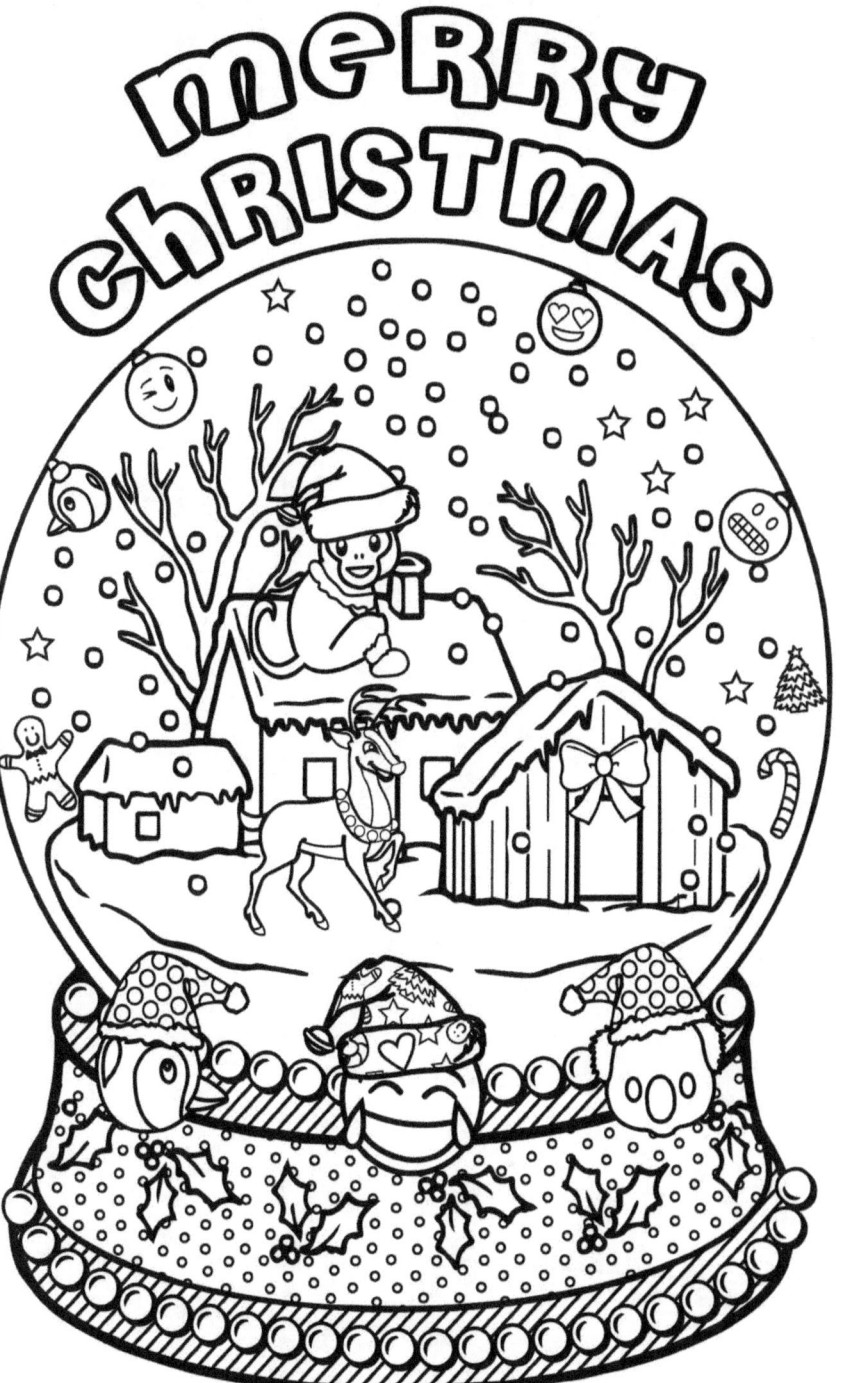

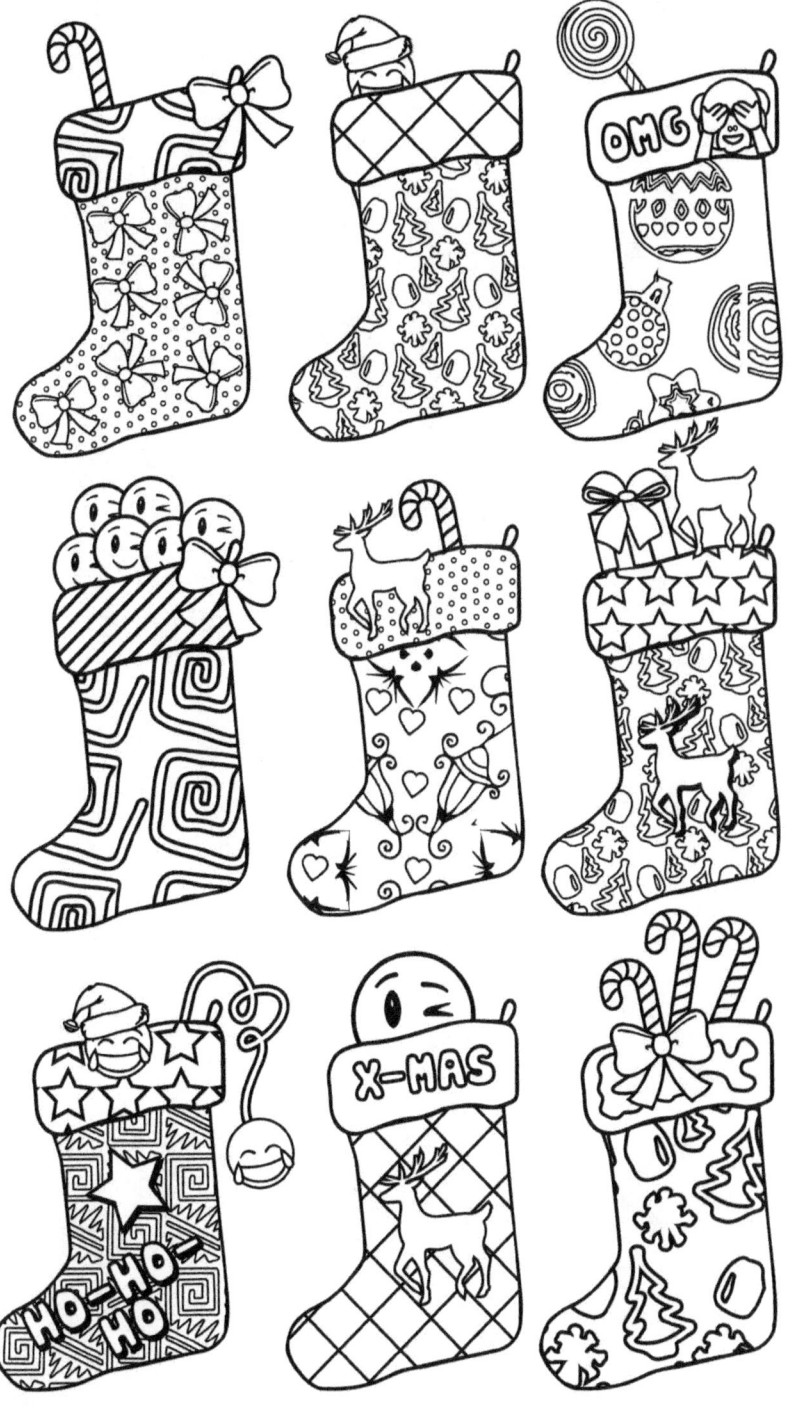

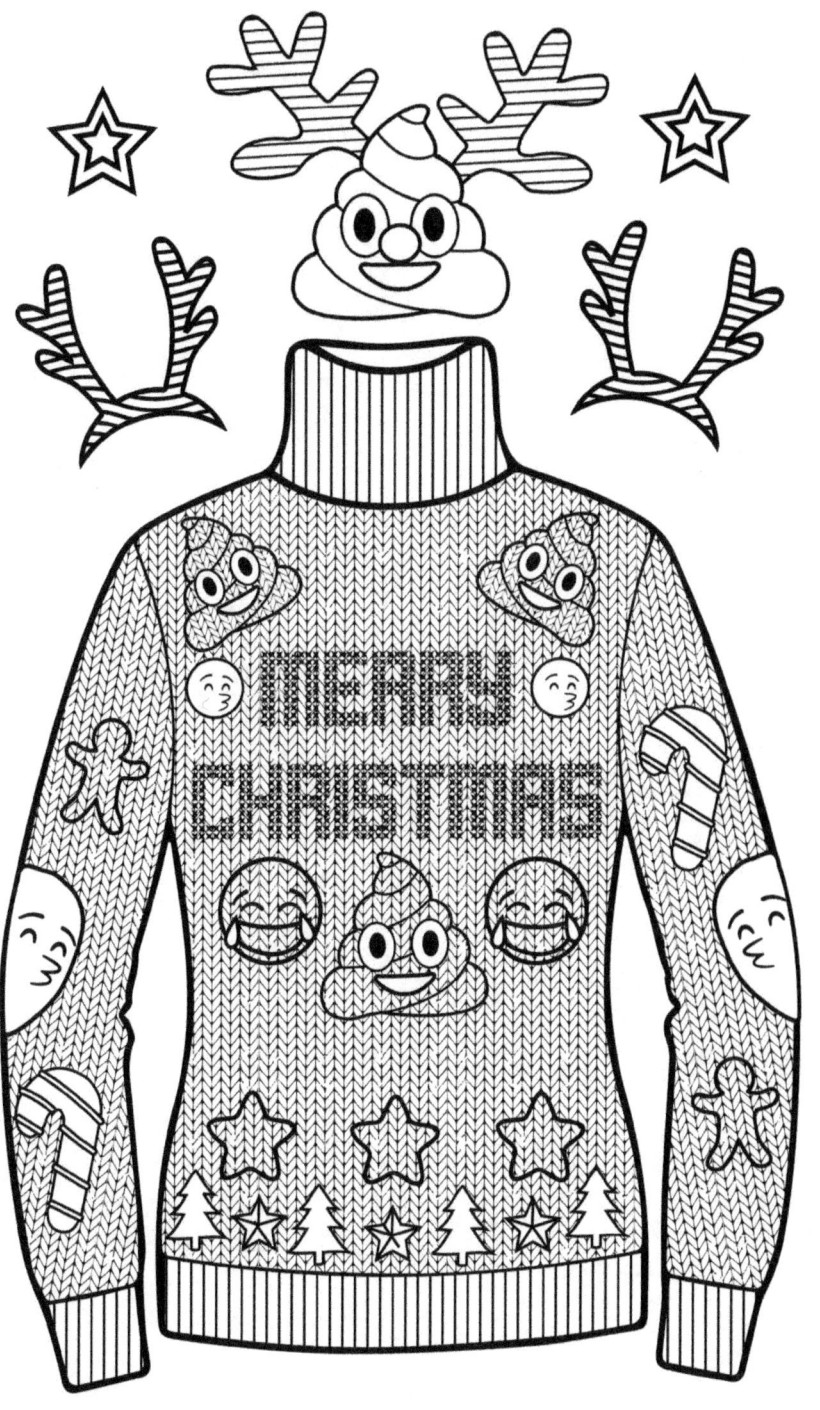

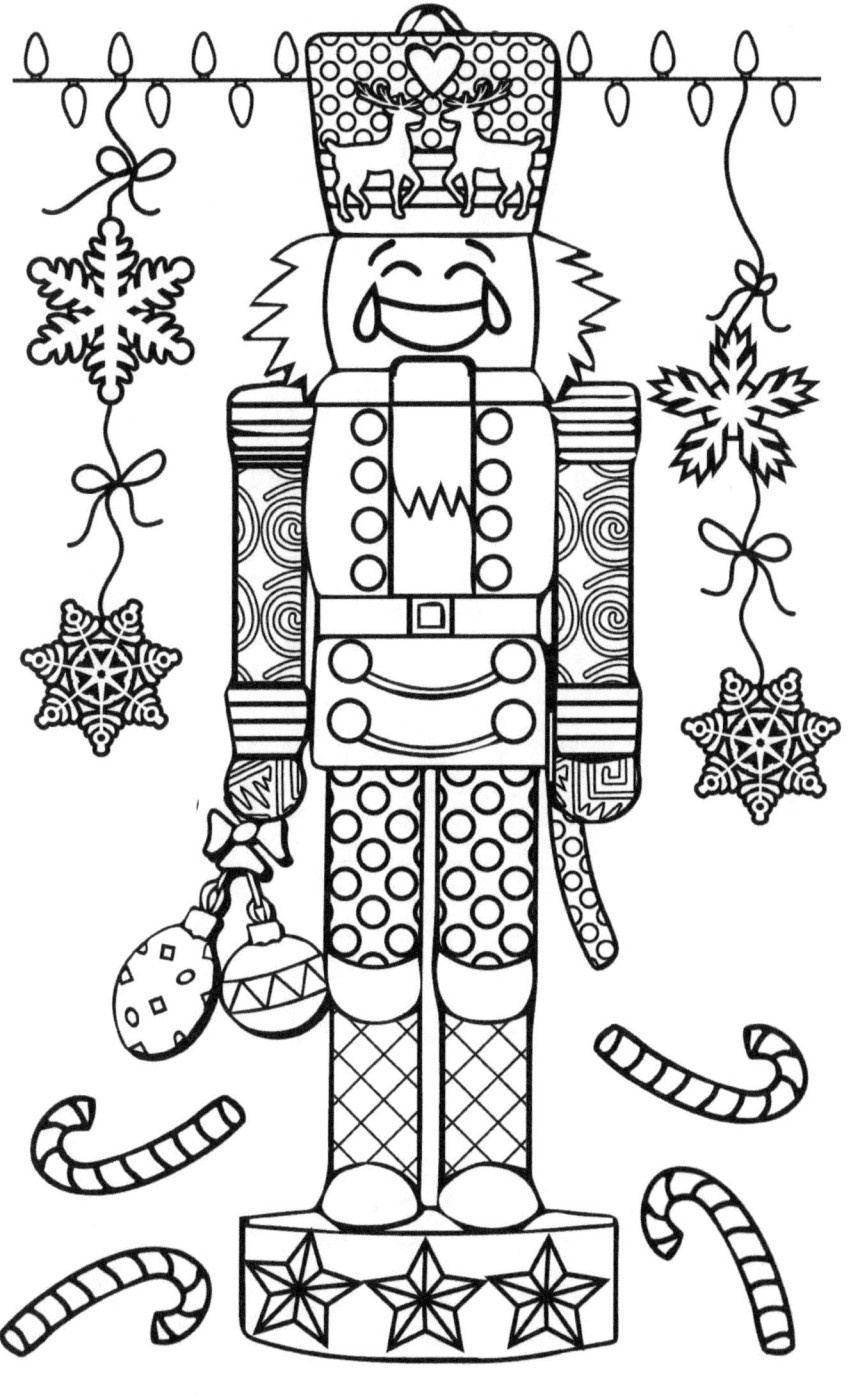

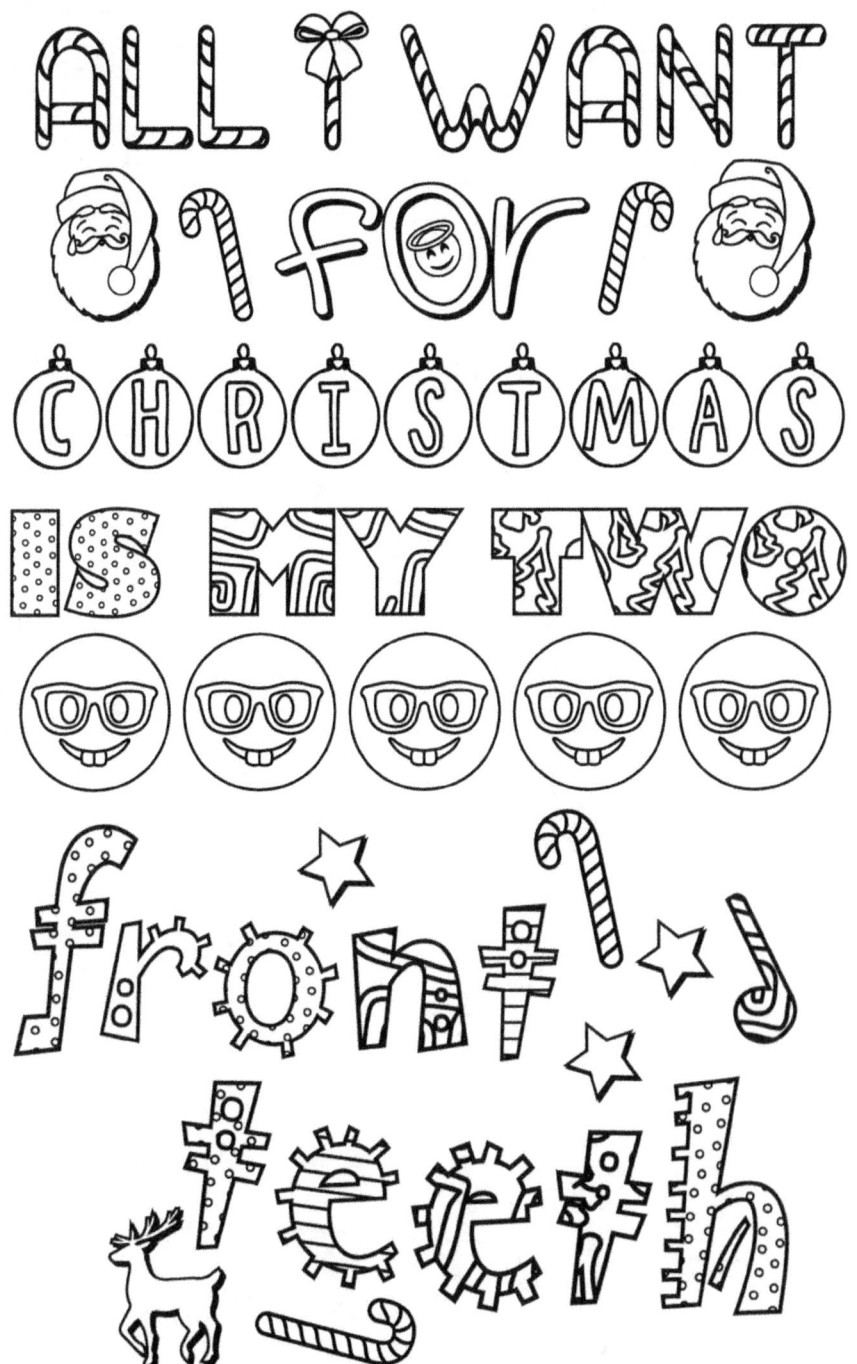

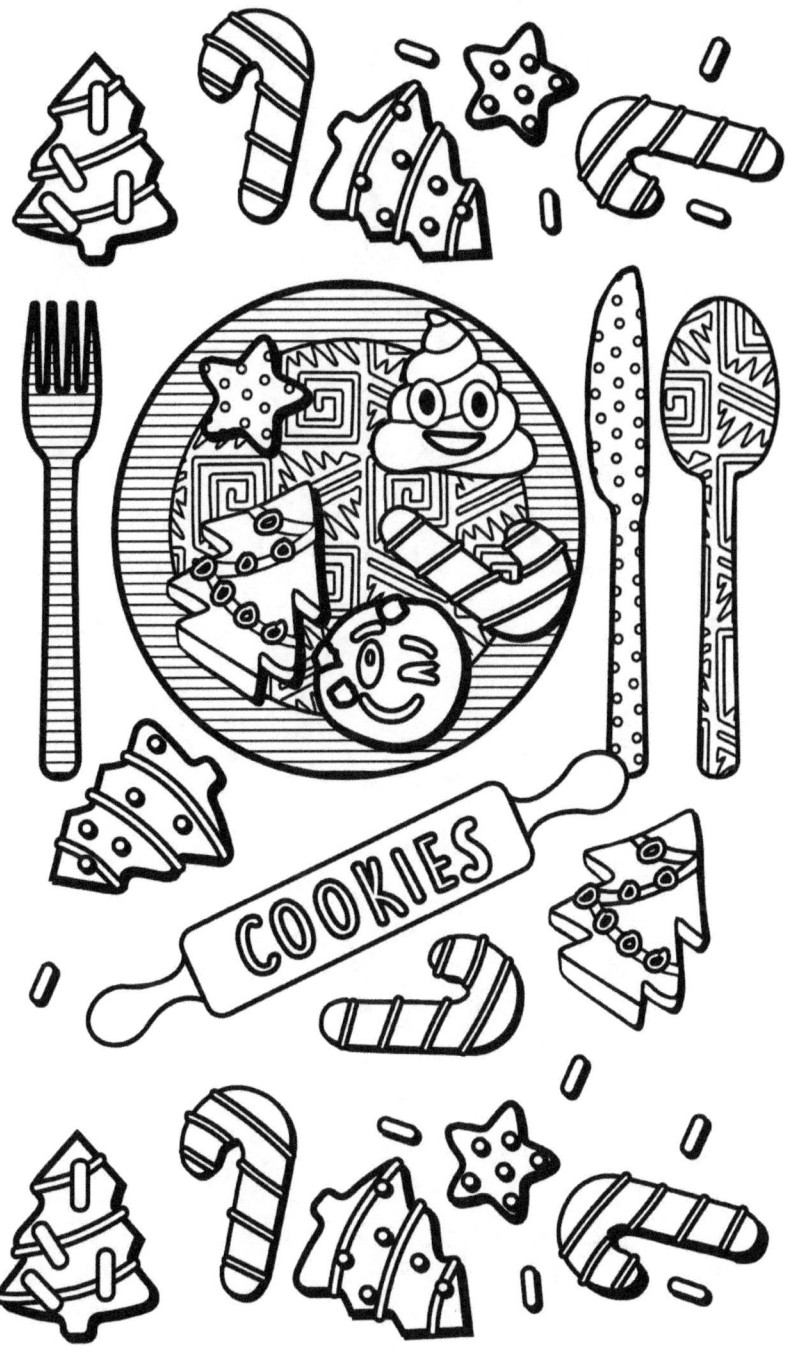

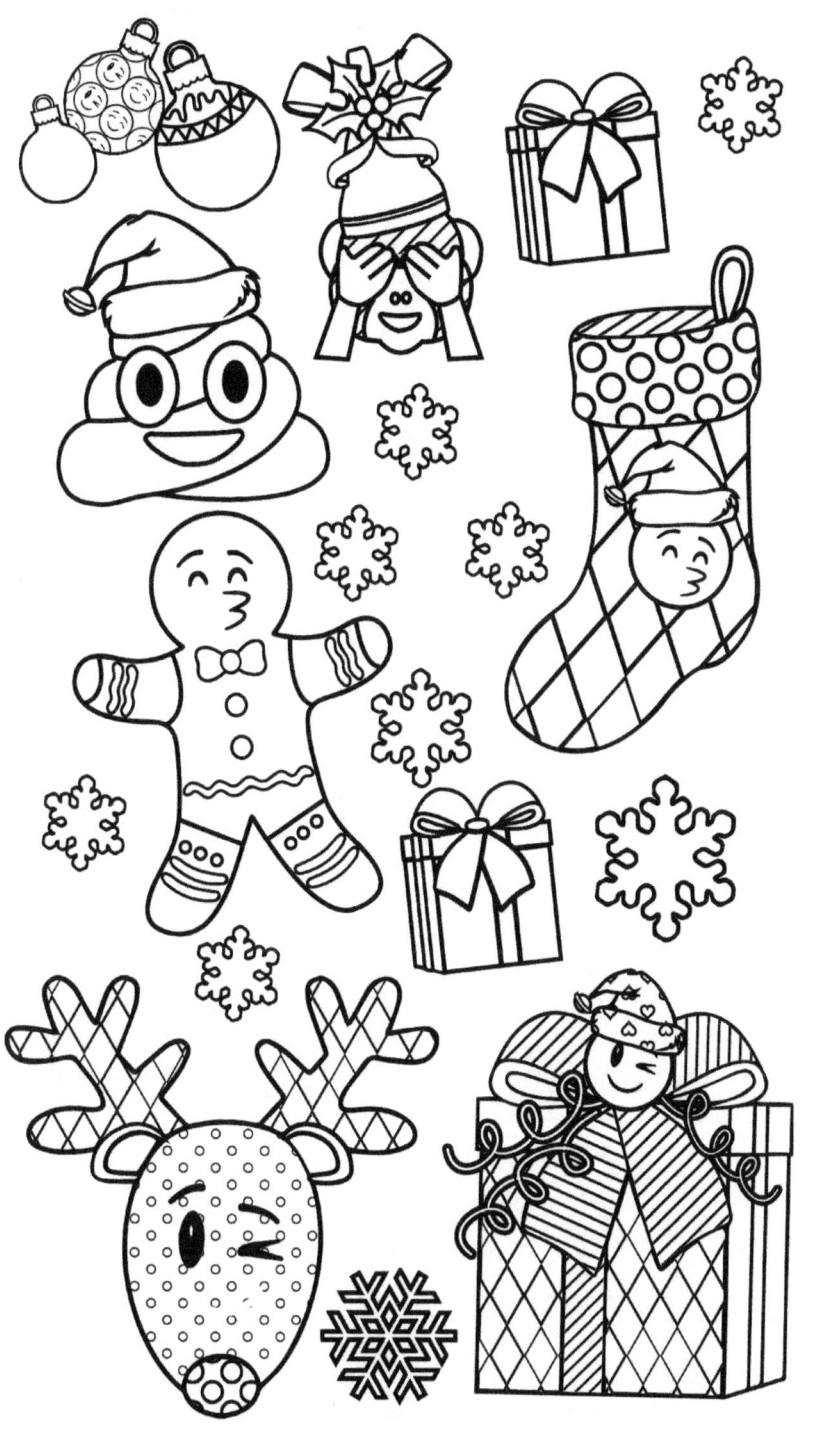

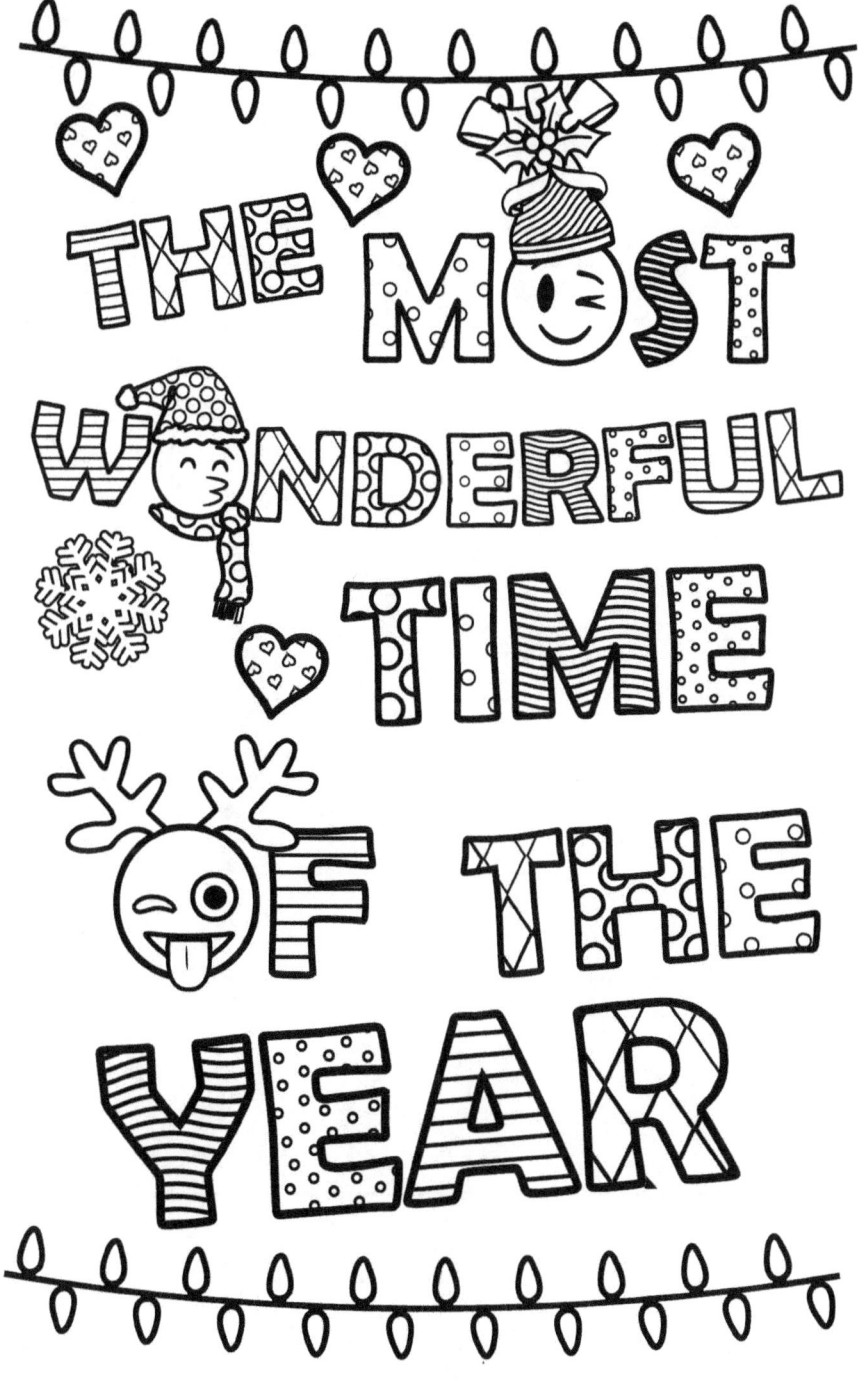

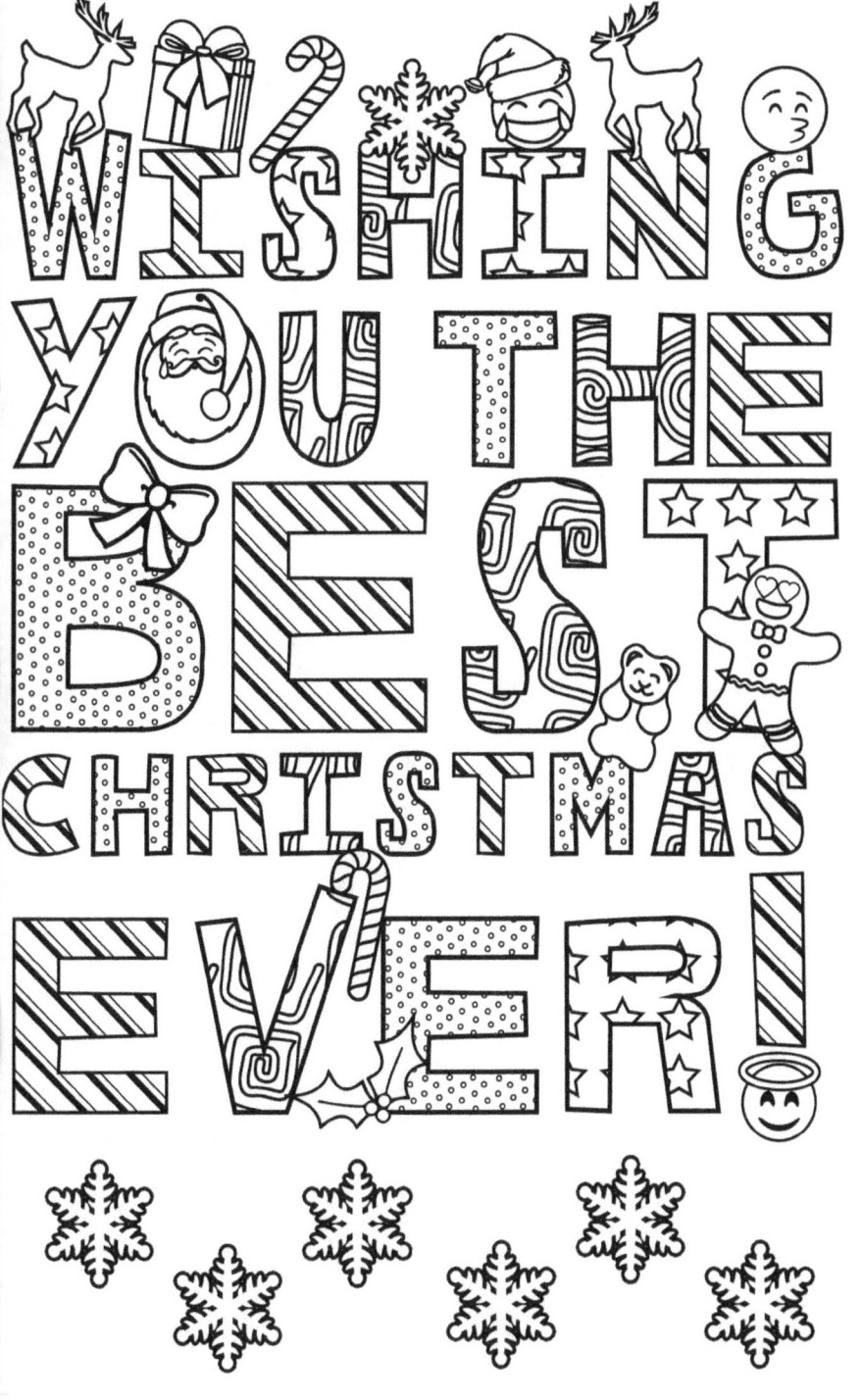

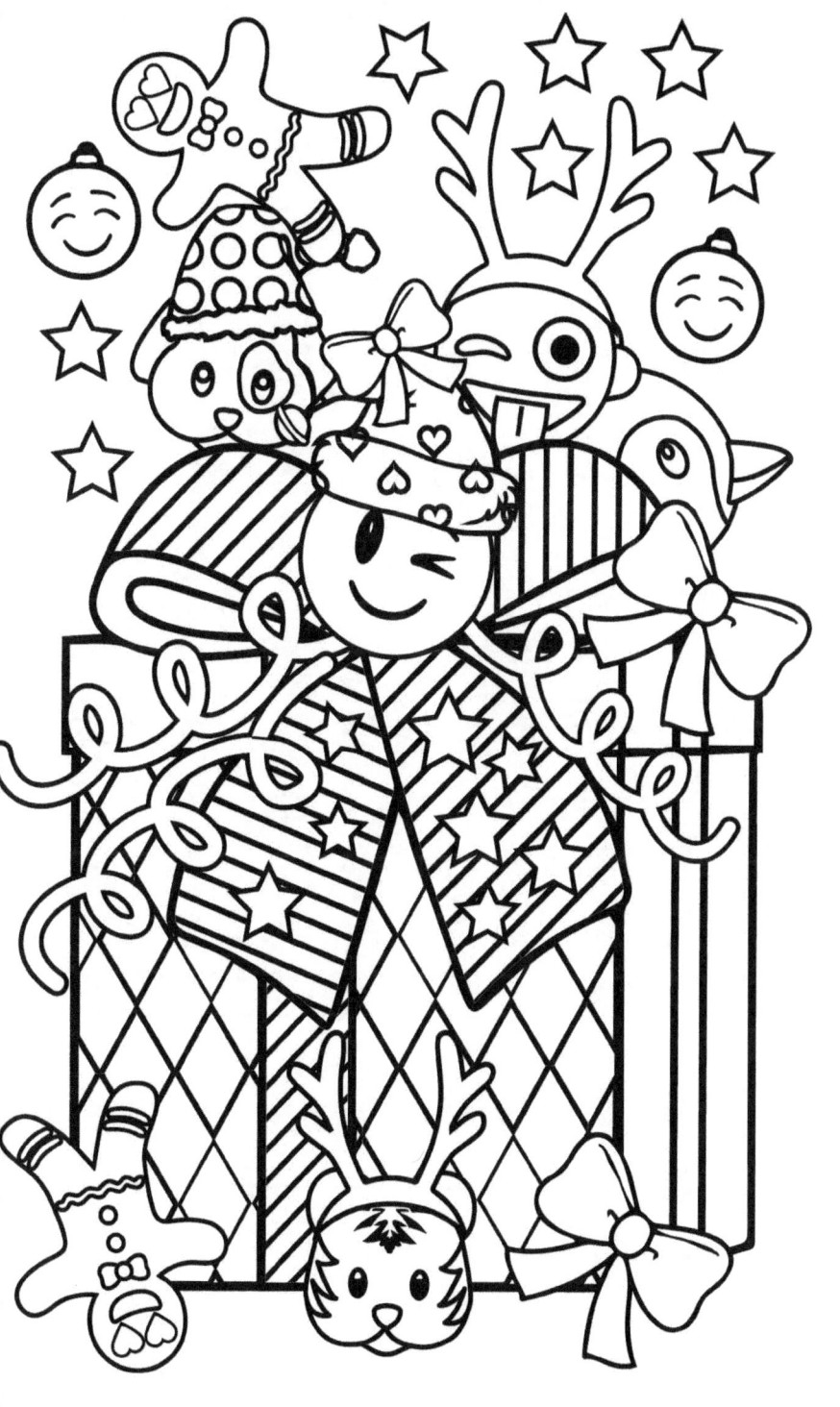

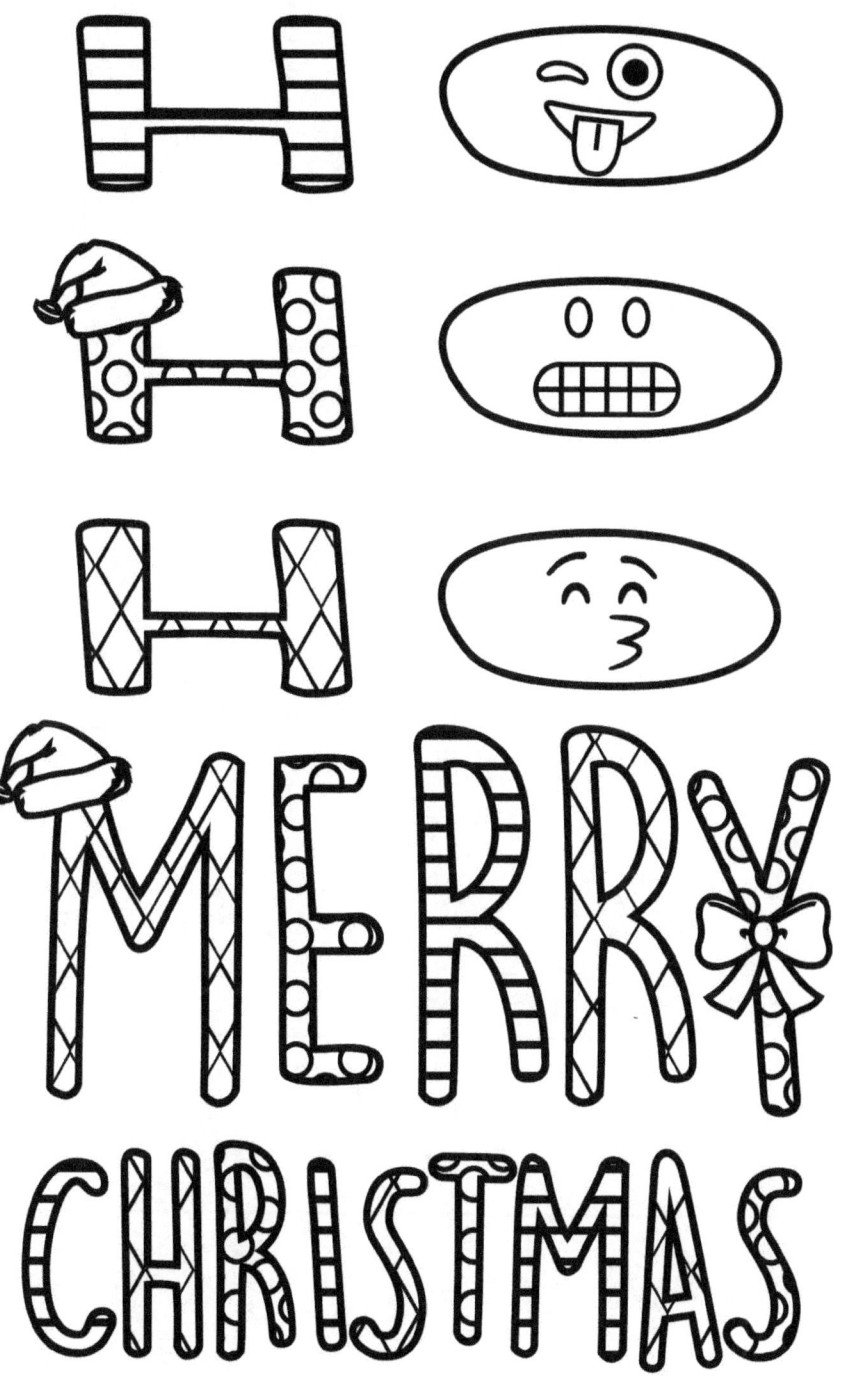

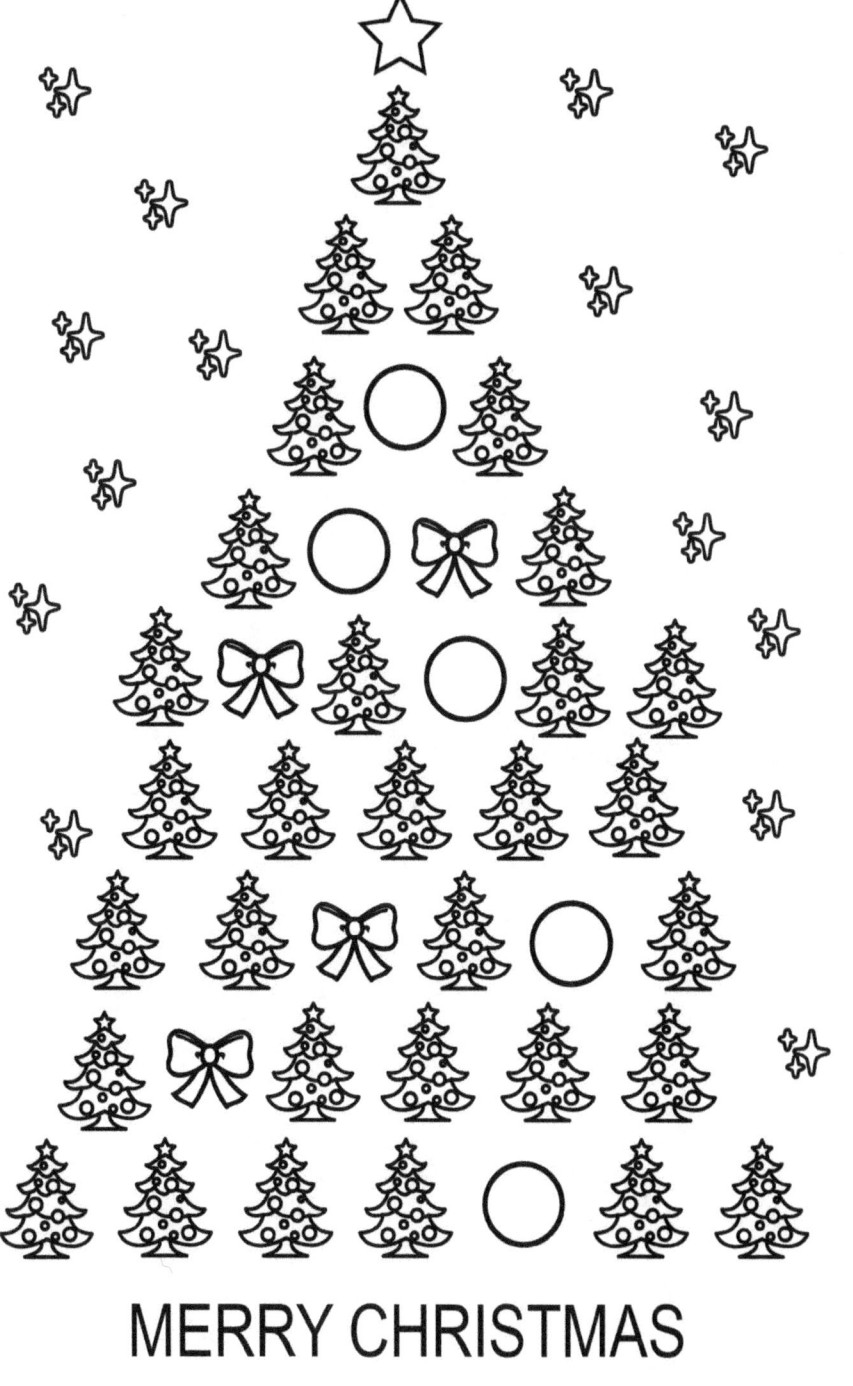

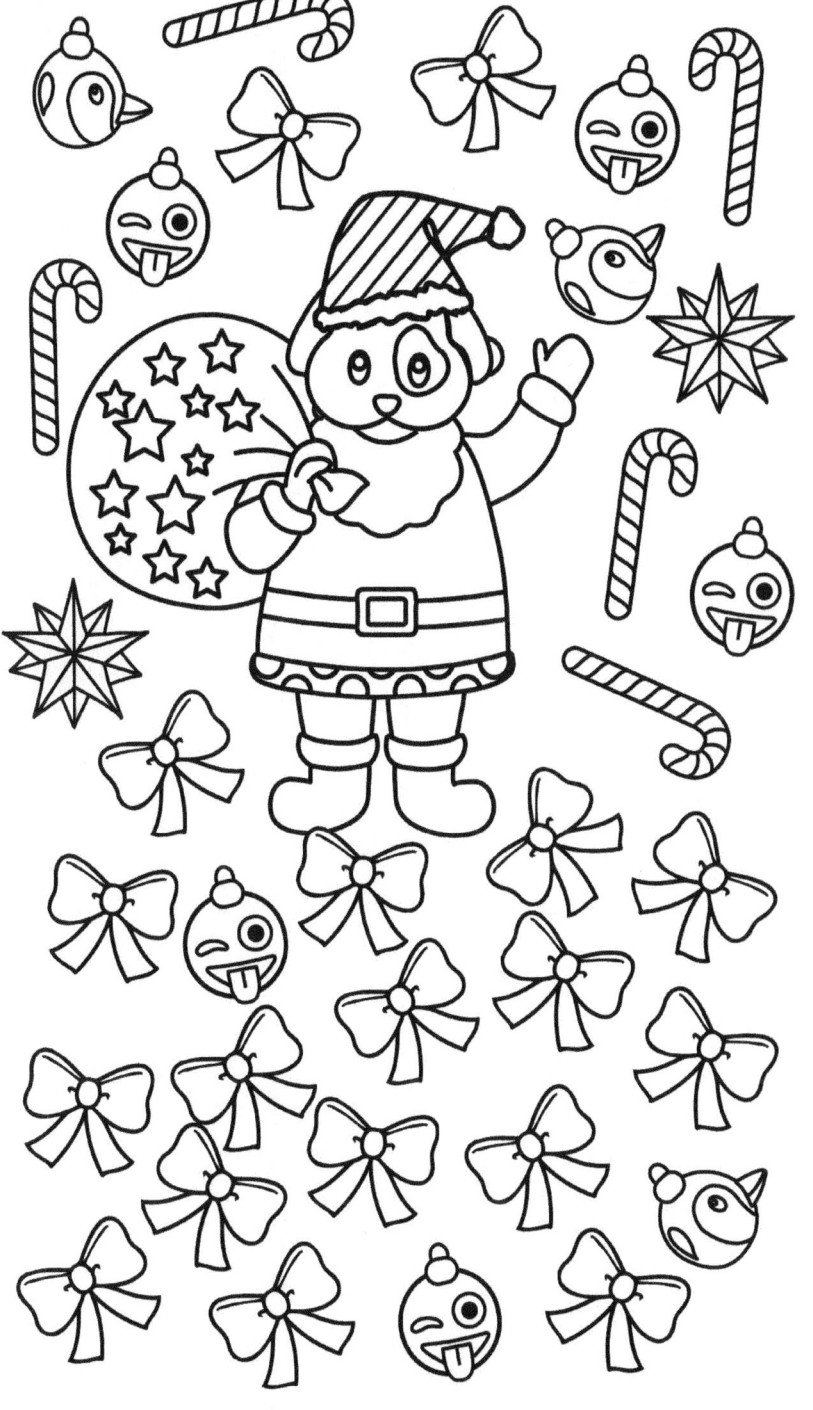

www.ingramcontent.com/pod-product-compliance
Lightning Source LLC
Chambersburg PA
CBHW061227180526
45170CB00003B/1189